Skeleton
and Bone
Reference
Points

Michel Lauricella

T0023180

rockynook

Morpho: Skeleton and Bone Reference Points
Michel Lauricella

Editor: Joan Dixon
Project manager: Lisa Brazieal
Marketing coordinator: Mercedes Murray
Graphic design and layout: monsieurgerard.com
Layout production: Hespenheide Design

ISBN: 978-1-68198-452-0
1st Edition (5th printing, March 2024)

Original French title: Morpho: Squelette repères osseux
© 2018 Groupe Eyrolles, Paris, France
Translation Copyright © 2019 Rocky Nook, Inc.
All illustrations are by the author.

Rocky Nook, Inc.
1010 B Street, Suite 350
San Rafael, CA 94901
USA
www.rockynook.com

Distributed in the UK and Europe by Publishers Group UK
Distributed in the U.S. and all other territories by Publishers Group West

Library of Congress Control Number: 2018955181

table of contents

5 foreword

6 introduction

15 drawings

17 head and neck

37 torso

57 upper limb

77 lower limb

96 resources

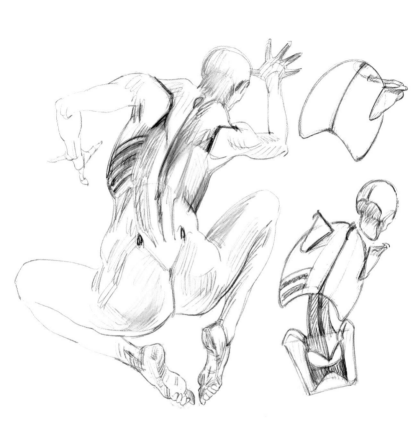

foreword

Gaining a knowledge of the human skeleton will help you construct your figures with imagination and will help you to grasp the body's mechanics so you can estimate the range of motion of each segment of the body. Building on this knowledge, we hope to enrich our drawings by observation, nuancing our pencil strokes, whether or not the skeletal structure is visible under the skin. Making the distinction between a fleshy form (whether made of muscle or fat) and a bony form may lead you to vary what you draw; alternating between softness and hardness, juxtaposing curves and angles, and varying downstrokes and upstrokes. This can be a way to accentuate the characteristics of your models who—regardless of their body shapes—all have bone reference points. Fat does not hide the entire skeleton and, in fact, might sometimes reveal its presence. In many places, the skin remains attached to the bones and forms depressions, dimples, or furrows. The body's movements will reveal the areas where these connections are located, and the skin's folds will betray their presence.

In this book, we find the bone reference points on the skeleton that are the most common and most useful for drawing the human figure. We will focus on a simplified version of the skeleton in order to stay as close as possible to the living form, our goal here being to improve our drawing without making it overly anatomical. Whenever the cartilages create shapes that appear hard, they are presented as belonging to the bone reference points. These include the nasal roof and the contours of the rib cage under the sternum, among others.

This book is organized by the sections of the body, according to the classical structure: head and neck, torso, upper limb, and lower limb.

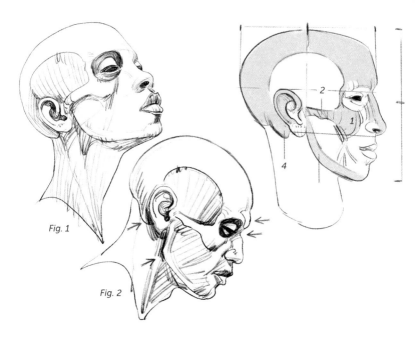

Fig. 1

Fig. 2

introduction

The way the skeleton looks under the skin will obviously vary depending on the thickness of your model's musculature and fat layers. In addition, the sturdiness of each model's skeletal structure will vary. On top of all this, the bones show evidence of the muscular tractions that constantly work on them: Every projection (tuberosity), ridge, crest, furrow, or torsion is an expression of this muscular activity and of the body's movements. Because a powerful musculature is most often a masculine characteristic, we assume that such a body will also have a skeleton

in proportion to that—in other words, a heavier, sturdier skeleton. Conversely, a lighter, more delicate, and slenderer skeleton is commonly more feminine. Other characteristics that we perceive as gendered will be addressed later.

In this book, we reduce all of the joints to two kinds of shapes: the sphere (condyle), which allows rotational movements in several directions (for instance the shoulder), and the pulley (trochlea), which only allows movements of flexion and extension (like the tip of the fingers).

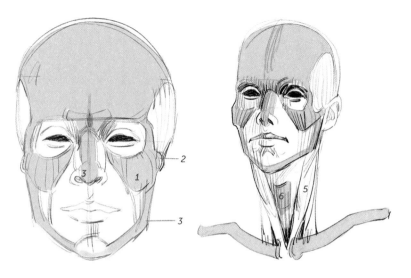

The Head and Neck

The skull is the basis for the most important shapes of the head, and provides valuable proportional guidelines, which we will quickly review here. We are talking here about the classic, canonical adult head (think da Vinci and Dürer). The eyes can be placed at halfway up on the head. This proportion will allow you to easily position the orbital frames. The cheekbones (1) are an extension of the shape of the eye sockets. Continuing along the sides, they are followed by the zygomatic arches (2), which come to an end in front of the ears, just at the level of the mandibular joints (3). This point is at the midpoint of the skull seen in profile. Certain characteristics can be more or less accentuated in one sex or the other, although, in fact, these shapes tend to be combined and blended. Neverthe-

less, it is possible to make a skull appear more feminine (Fig. 1) by drawing the forehead more vertically and softening the angle of the jaw. Or the head can be rendered more masculine (Fig. 2) by thickening the whole at the expense of the openings (the orbital and nasal pits) and reinforcing the angle of the jaw as well as the eyebrow ridges (which will create a depression at the bridge of the nose). All of these characteristics indicate a more powerful bone structure and are connected with greater muscular strength in the jaw.

Notice, at the back of the ear, the mastoid (4), which is the insertion area for the head's rotator muscle (5, sternocleidomastoid).

The thyroid cartilage, or Adam's apple (6), forms a protrusion on the front of the throat. On a female model, this shape will be more discreet.

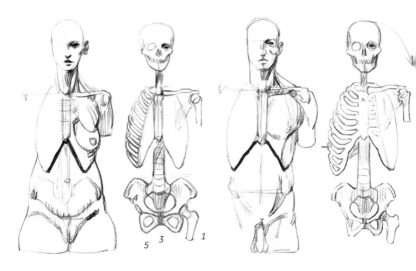

The Torso

The rib cage is made up of a dozen pairs of ribs, connected at the spinal column at the back and at the front by the rib cartilages at the sternum. We consider the rib cartilages as hard reference points, and therefore "bony" in the context of this little book. The rib cage can differ from one person to the next because of the extent of these cartilages, which form a broader or narrower inverted V depending on the individual. A more closed rib cage is the main contributor to a narrow-waisted effect.

Imagine the first pair of ribs at the back of the neck, starting from the first protruding vertebra at the base of the neck (the last cervical vertebra, which is often very pronounced and prominent), and coming together at the top of the sternum. The orientation of this first pair of ribs corresponds, roughly speaking, to a necklace worn at the neck. All the ribs are approximately parallel to each other, so you will find this circular orientation everywhere the rib cage touches the skin. The ribs' widest points are above the waist, under the chest and breasts in the front, and under the shoulder blade (scapula) in the back.

The pelvis connects the spinal column to the femurs (1), following a pelvic ring, which, from the sacrum (2, five vertebrae fused together) in the back, comes around to reconnect in the front at the cartilage of the pubis (3, a true shock absorber).

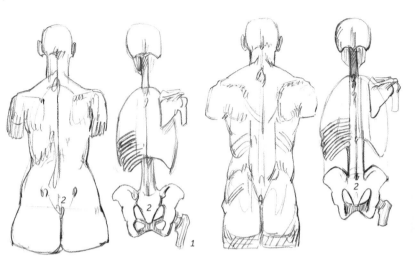

The hip joints are positioned midway along the sides of this ring. So that there will be enough surface area for the insertion of the muscles that support the torso above and operate the lower limbs below, there are two large bone plates, above and below this ring. The upper plates (4, iliac wings, or ilium) start at the hip joint and rejoin the sacrum in the back. The lower plates (5, ischium), which start in the same place, meet in the front. We will complete this description later, with more drawings.

I don't think it is very important to remember the number of vertebrae (7 cervical, 2 dorsal or thoracic, and 5 lumbar) since only the top cervical vertebra is visible. And even when the dorsal and lumbar vertebrae can be seen, partic-ularly in postures that involve leaning forward, a simple series of small hard protuberances, with blunt summits, can be a good indication of their presence in this position. By contrast, in the standing position there should be small dimples in the kidney area, because the muscles in that area are more prominent in that position. The proportions of these three sections of the spine—if we simplify them somewhat so these are not completely precise—are about 6 inches (for the cervical vertebrae), 12 inches (for the dorsal vertebrae), and 8 inches (for the lumbar vertebrae). In the standing position, the pubis is halfway between the top of the head and the bottom of the foot.

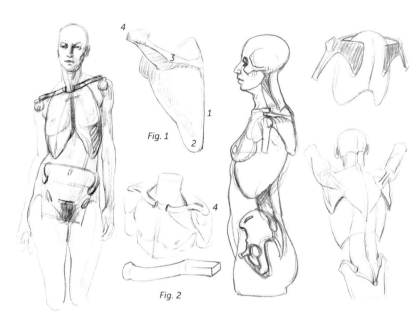

Fig. 1

Fig. 2

Visually, the scapular belt (the shoulder blades, scapulae, and clavicles) belong to the torso, but mechanically, they are the first bones of the upper limb. Every movement of the arm is driven by a movement of the scapula (Fig. 1) and the clavicle (Fig. 2). The clavicle, which is subcutaneous, can be drawn using two curves: The first curve (2/3 of its length) starts at the sternum and clings to the curvature of the rib cage and the second curve (1/3) connects with the scapula as it overhangs the shoulder joint. The scapula is a bony platform (similar to the iliac wing of the thigh), which makes all the muscle movements possible for the broad and varied positions of the arm (rotation, raising,

lowering, etc.). This bone remains subcutaneous at its spinal edge (1), its tip (2), and its ridge (3), and its extremity (4, acromion) connects with the clavicle. The scapulae benefit from a broad surface area with which to slide across the rib cage. If this bone were in a fixed position on the back, we would not be able to raise our arm above the horizontal position. To go further than that, the scapula has to tilt and face upward. In this motion, it is aided by the clavicle, which works as a pivot axis. The clavicle, too, follows the motions of the arms. Its connection to the sternum is the upper limb's only bone contact with the torso, which also attests to the large range of the movements of the arm.

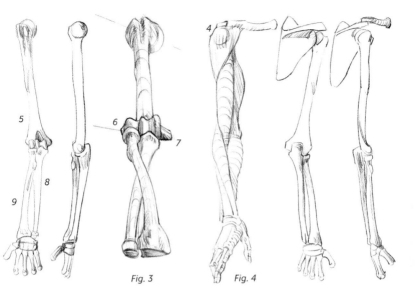

Fig. 3 *Fig. 4*

The Upper Limb

The humerus (5) is the bone of the upper arm. Its rounded head takes shape under the deltoid in front and on the side (unless this muscle is hyper developed), whereas the spine of the scapula extends beyond it in the back. Thus, the shoulder is rounded in the front and flatter in the back.

The humerus reappears at the elbow, where it is responsible for two bony points (Fig. 3): on the outside, the lateral epicondyle (6), where the extensors that run down the back of the hand and the fingers are attached; and on the inside, the medial epicondyle (7), for the flexors that connect with the palm of the hand and fingers. Note that this second bony point is much more prominent: In fact, we have more strength for picking things up (bending the fingers) than for letting them go. Between these two

bony points, are two side-by-side joints: a pulley for the ulna (8) for movements of flexion and extension, and a sphere for the radius (9) for rotations. The radius can rotate around the ulna and accompany it in its flexing movements.

On the forearm, the ulna remains below the skin from the elbow to the wrist (on the side of the little finger, where it creates a rounded protrusion). This bone is an excellent reference point for drawing. The radius, for its part, is only visible at its extremities. It can be seen right next to the condyle of the humerus, and it gives the extremity of the forearm its flattened and quadrangular shape. The muscles (Fig. 4) follow the paths of the bones.

The eight small bones of the wrist form two rows, with prominent edges that provide lovely guides on the heel of the hand (Fig. 1). The metacarpals (1)

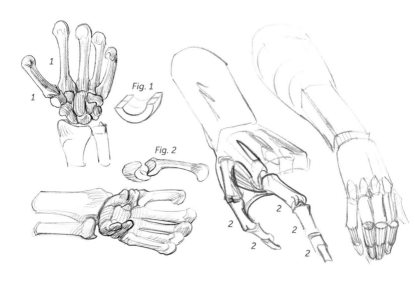

Fig. 1

Fig. 2

are outlined under the skin along the line of the fist. When the fist is closed, their spherical heads (knuckles) protrude. On a chubby hand, these joints correspond to the dimples at the base of the fingers.

The thumb deserves special attention here. It is not on the same plane as the fingers: At rest, the thumb is angled perpendicularly to the palm. Its great mobility is made possible by a saddle joint (Fig. 2). It only has two phalanges (2), while the fingers each have three. The phalanges are jointed through pulley joints (for flexion and extension only), whose edges can be seen along the back of a bent finger.

The radius and ulna are about 3/4 the size of the humerus. The upper limb, measured from the top of the shoulder (the clavicle) to the heads of the metacarpals (the fist), can be divided in half at the elbow. The hand, measured from the head of the ulna (the little bump above the wrist on the side of the little finger) to the end of the longest finger, can be divided in half at the heads of the metacarpals. The first phalange of each finger (except for the thumb) is as long as the two following phalanges put together.

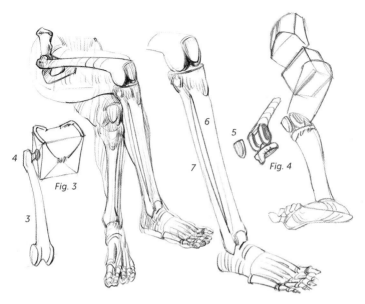

Fig. 3

Fig. 4

The Lower Limb

The pelvis, or pelvic girdle (like the scapular belt for the upper limb), is a bone structure that connects the torso and the lower limbs. The femur or thighbone (3), the bone of the thigh (Fig. 3), has a spherical articulation (rotation) with the pelvis. The femoral neck (the submerged part of the femur) forms an elbow shape with the main part of the femur. Where the femoral neck meets the body is the trochanter (4), which is interesting to us because it is subcutaneous. Using this bone reference point, we can imagine the joint, which is deep and hidden. The trochanter looks like a protrusion on thinner models or like a hollow on models with more flesh. The femoral neck redistributes the axis of the femur, which should not be imagined as falling vertically inside your thigh. By imposing its direction on the muscles (particularly the powerful quadriceps), the femoral neck is responsible for the shape of the thigh.

At the knee, under the skin, we find the end of the femur, connected with the patella (5) and with the bones of the leg itself—the tibia (6) and the fibula (7). The shape of this region is essentially made up of bone: The femur, tibia, and patella are responsible for its structure (Fig. 4). The fibula is secondary, and only its extremities are visible and can be seen at the outside of the knee in the shape of a small bump or dimple (again, depending on whether your model is thin or fleshy), and again, on the outer side of the foot, in the shape of the ankle (external or lateral malleolus). As for the tibia, it is visible along its entire length, from the knee to the ankle (internal or medial malleolus), and it structures the entire shape of the leg. The tibial plateau receives the femur (and the weight of the entire body!), and is therefore large. Notice that in the front, below the patella, there is a protruding bone reference point that indicates the insertion point of the quadriceps.

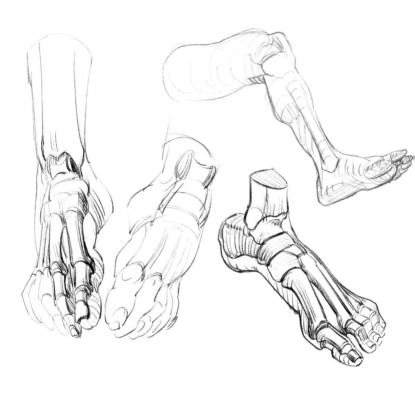

There are many similarities between the hand and the foot: five fingers or toes, structured in the same way, the same number of phalanges (with, in each case, one fewer for the thumb and for the big toe), and the same kinds of joints. The foot, however, is constrained by our bipedal posture and, except with a flat foot, the plantar arch is responsible for the foot's arched back and for the corresponding hollow below. This arch plays a shock-absorbing role, collecting the weight of the body. As with the hand, the foot is bony on top and fleshy on the bottom.

The proportions of the lower limb are simple: From the trochanter to the ground, the halfway point can be placed at the knee joint. In other words, the length of the thigh is the same as the length of the lower leg plus the height of the foot. We can sit on our heels.

All the proportions given in this book are for reference only and are intended to simplify your learning process. With live models, you will encounter many variations.

drawings

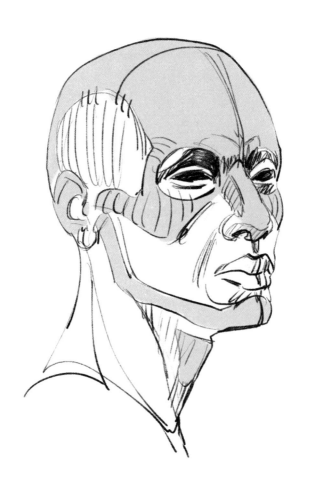

head and neck

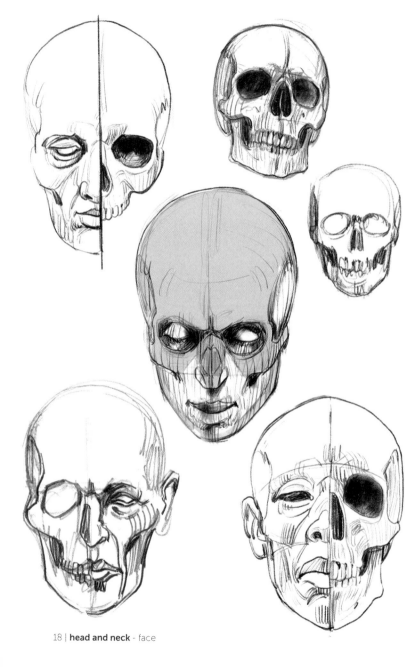

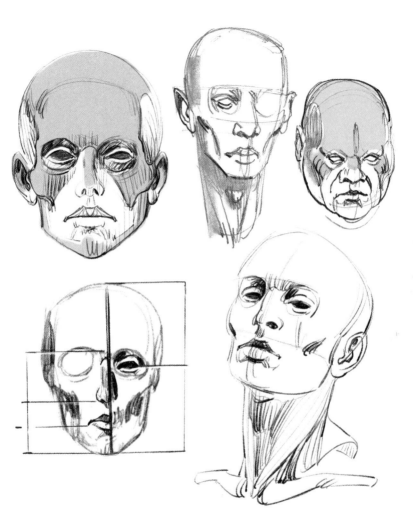

The shaded areas on these drawings correspond to the areas where the bone structure dominates the shape.

The forehead, the eye-socket frames, the cheekbones, the edges of the lower jaw, and the cartilages of the nose and ears provide hard markers under the skin.

The point of the chin is often thickened by a fleshy mass: It can be hard to say whether to consider that a fleshy or a bony reference point. We will leave it up to you to be the judge of which to choose, depending on your model.

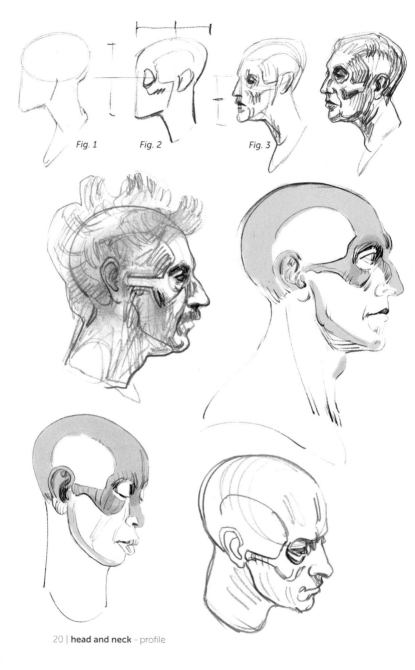

Fig. 1

Fig. 2

Fig. 3

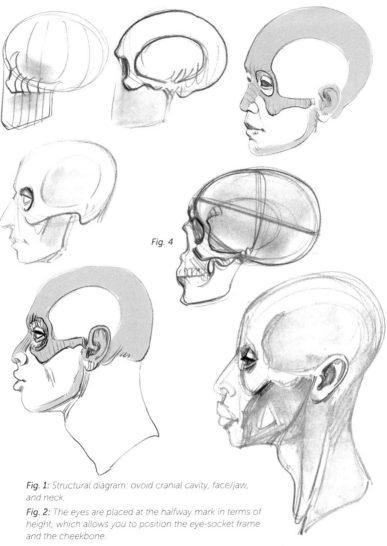

Fig. 1: Structural diagram: ovoid cranial cavity, face/jaw, and neck.

Fig. 2: The eyes are placed at the halfway mark in terms of height, which allows you to position the eye-socket frame and the cheekbone.

The lower jaw is connected below the cranial cavity, the halfway mark on the profile.

Fig. 3: A line extended from the bridge of the nose meets the tip of the chin. The ear aligns horizontally with the bridge of the nose.

Fig. 4: The oblique axis of the ovoid cranial cavity.

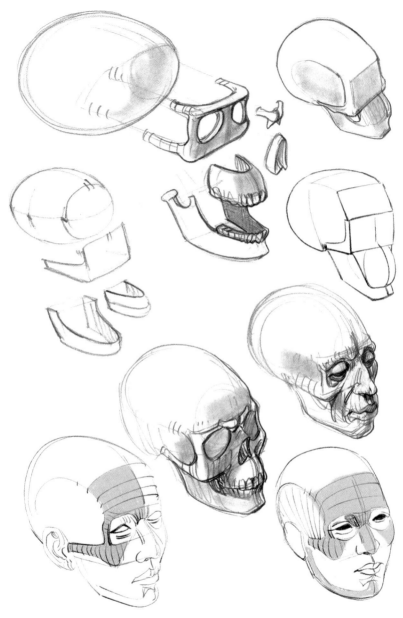

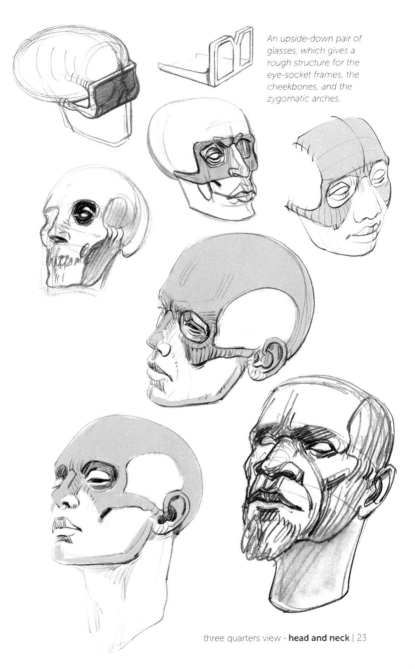

An upside-down pair of glasses, which gives a rough structure for the eye-socket frames, the cheekbones, and the zygomatic arches.

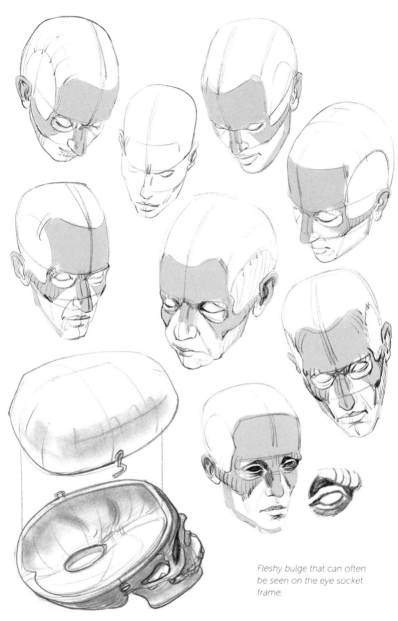

Fleshy bulge that can often be seen on the eye socket frame.

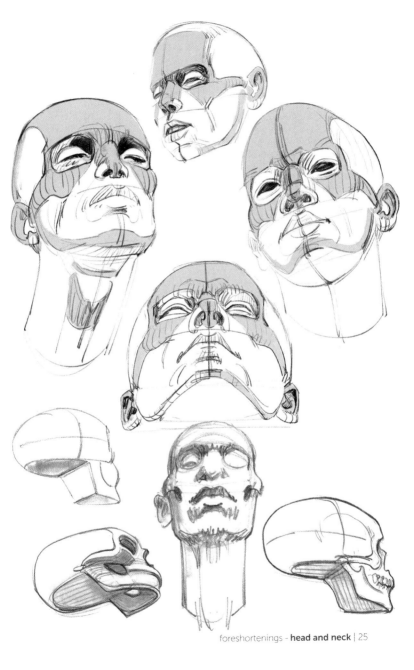

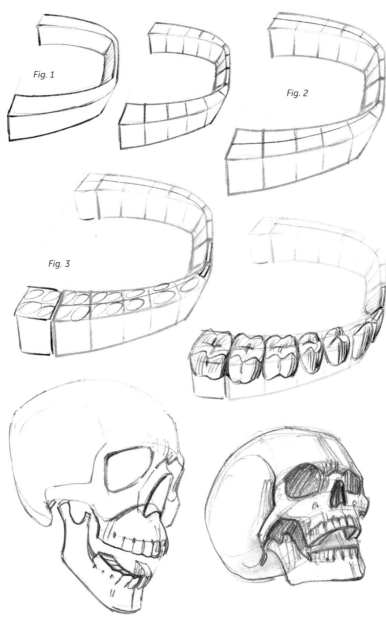

Fig. 1

Fig. 2

Fig. 3

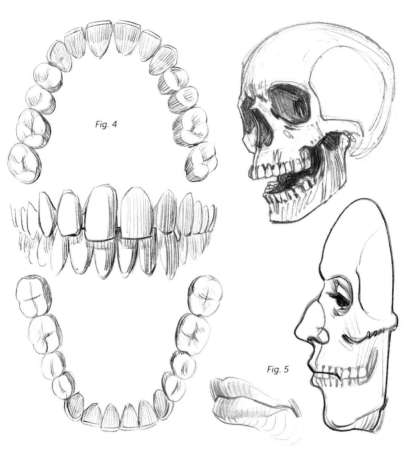

Fig. 1: The incisors (front teeth with 4 on top and 4 on bottom) are aligned and form a sharp bar. The molars, meanwhile, are placed on a curve and become wider toward the back.

Fig. 2: You can imagine a structural line that begins at the top of the incisors and then divides the top of the posterior teeth in half.

Fig. 3: On the upper surface of these teeth, we can start schematically and systematically positioning the various tips on either side of that dividing line: a single tip (on the outside) for the cuspid, two for the bicuspids, and four for the molars.

Fig. 4: The two dental arches. The upper arch, which is wider, covers the lower incisors and the molars make contact at the back.

Fig. 5: The closed mouth. The gap between the lips should, in theory, be placed at the midline of the upper incisors.

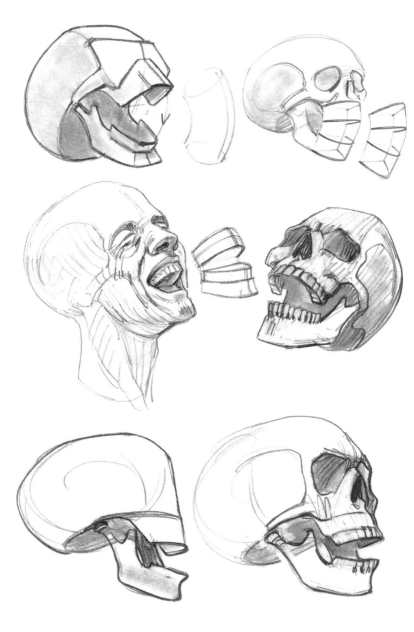

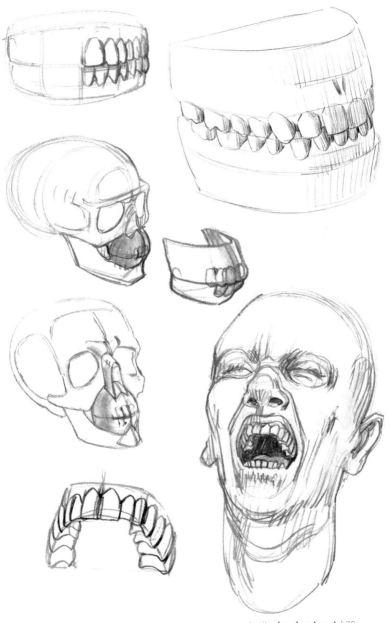

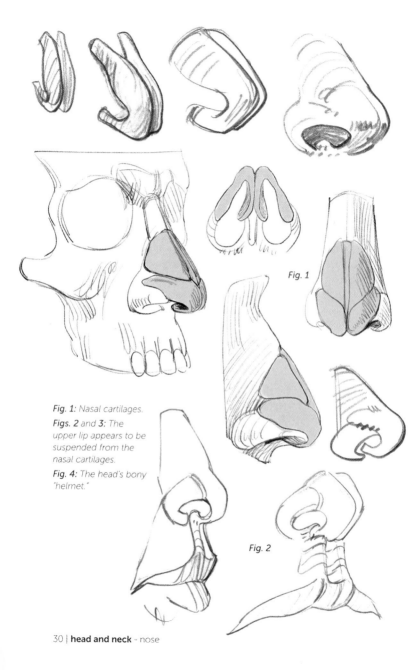

Fig. 1: Nasal cartilages.
Figs. 2 and 3: The upper lip appears to be suspended from the nasal cartilages.
Fig. 4: The head's bony "helmet."

Fig. 1

Fig. 2

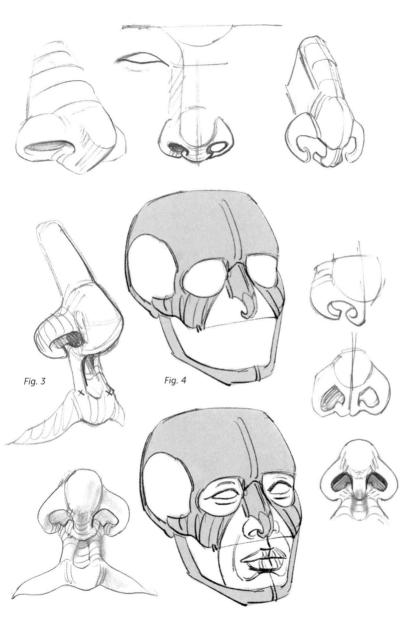

Fig. 3

Fig. 4

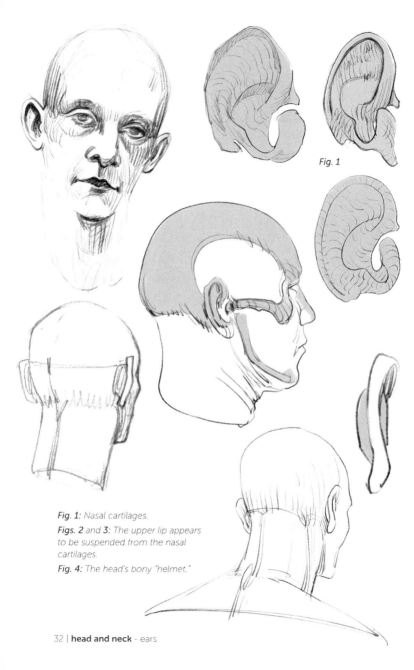

Fig. 1

Fig. 1: Nasal cartilages.

Figs. 2 and *3:* The upper lip appears to be suspended from the nasal cartilages.

Fig. 4: The head's bony "helmet."

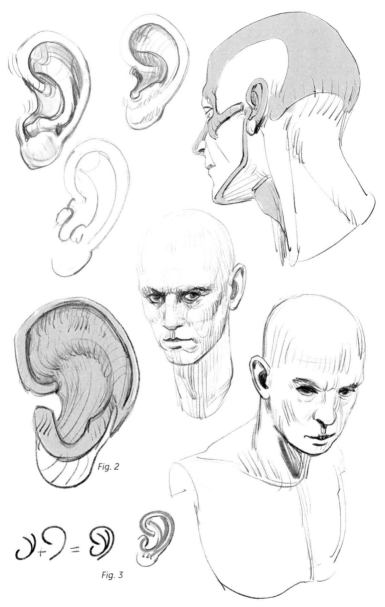

Fig. 2

$\mathcal{J} + \mathcal{I} = \mathcal{I}$

Fig. 3

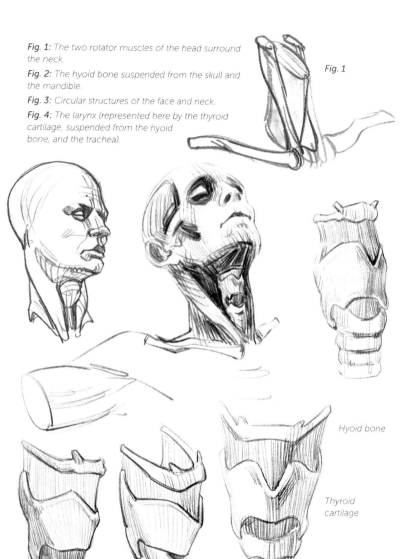

Fig. 1: The two rotator muscles of the head surround the neck.

Fig. 2: The hyoid bone suspended from the skull and the mandible.

Fig. 3: Circular structures of the face and neck.

Fig. 4: The larynx (represented here by the thyroid cartilage, suspended from the hyoid bone, and the trachea).

Fig. 1

Hyoid bone

Thyroid cartilage

Trachea

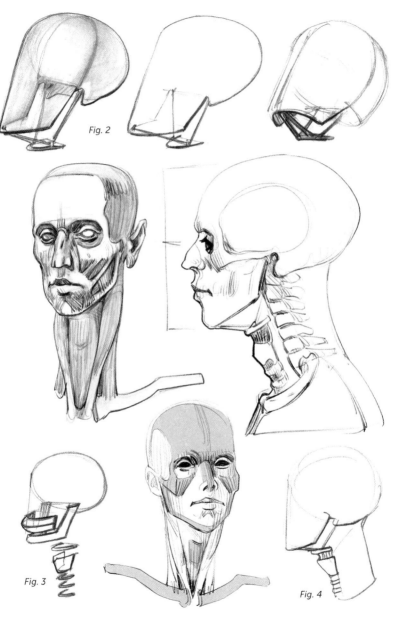

Fig. 2

Fig. 3

Fig. 4

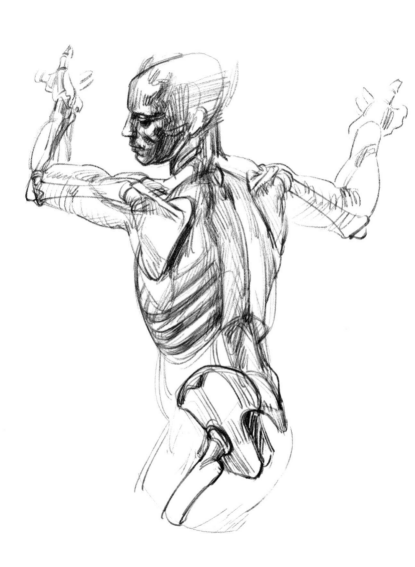

torso

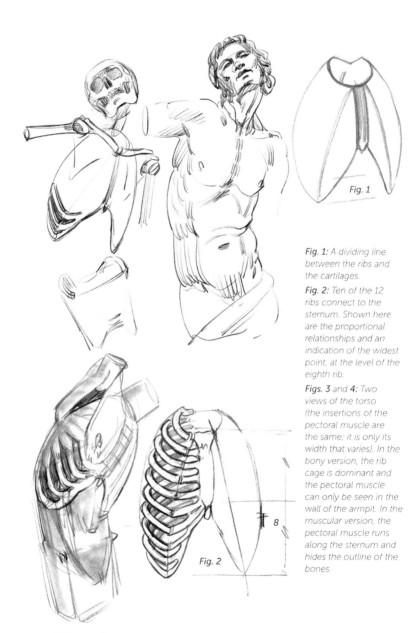

Fig. 1: A dividing line between the ribs and the cartilages.

Fig. 2: Ten of the 12 ribs connect to the sternum. Shown here are the proportional relationships and an indication of the widest point, at the level of the eighth rib.

Figs. 3 and **4:** Two views of the torso (the insertions of the pectoral muscle are the same; it is only its width that varies). In the bony version, the rib cage is dominant and the pectoral muscle can only be seen in the wall of the armpit. In the muscular version, the pectoral muscle runs along the sternum and hides the outline of the bones.

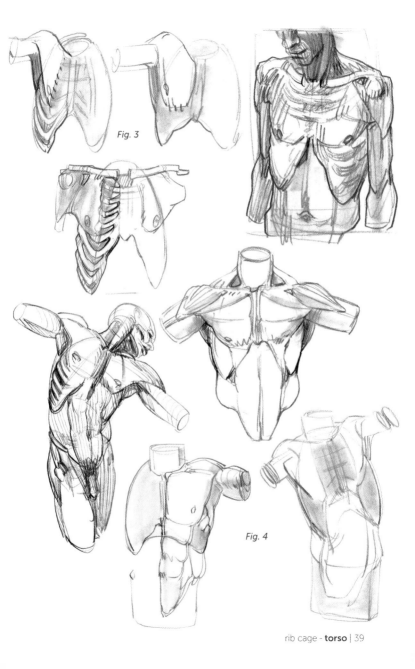

Fig. 3

Fig. 4

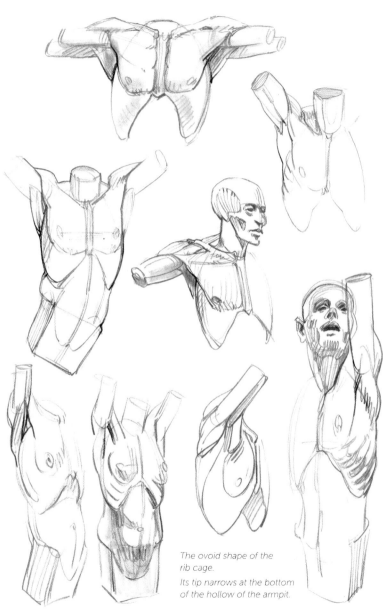

The ovoid shape of the rib cage.

Its tip narrows at the bottom of the hollow of the armpit.

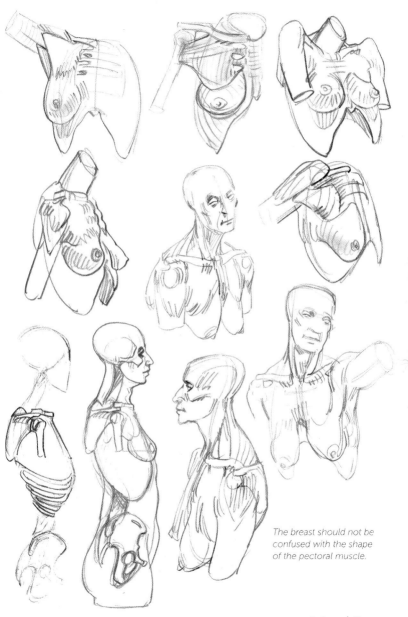

The breast should not be confused with the shape of the pectoral muscle.

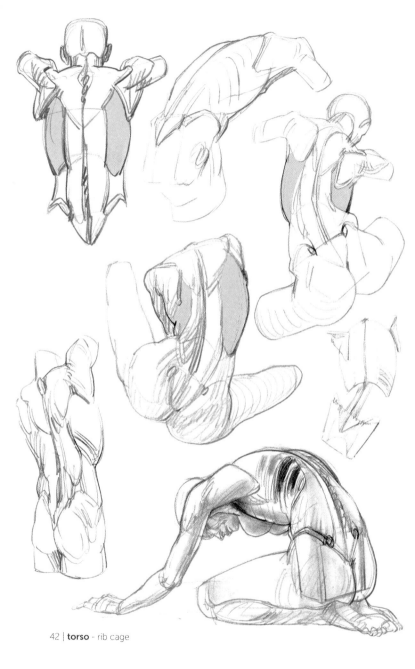

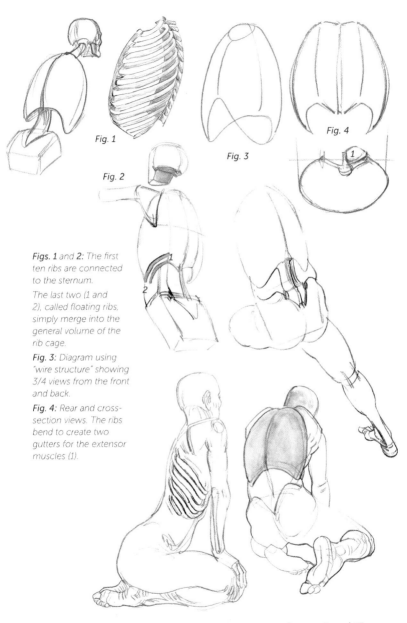

Fig. 1

Fig. 2

Fig. 3

Fig. 4

Figs. 1 and *2:* The first ten ribs are connected to the sternum.

The last two (1 and 2), called floating ribs, simply merge into the general volume of the rib cage.

Fig. 3: Diagram using "wire structure" showing 3/4 views from the front and back.

Fig. 4: Rear and cross-section views. The ribs bend to create two gutters for the extensor muscles (1).

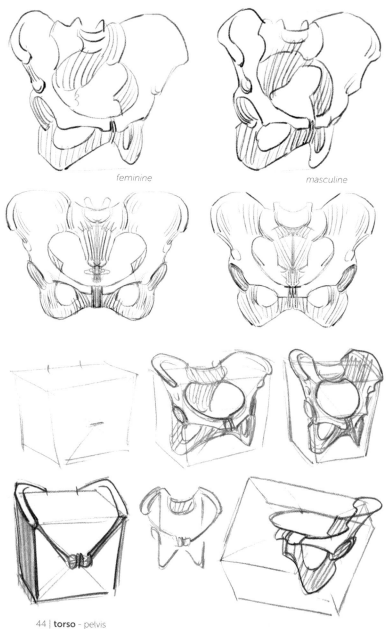

feminine　　　　　　　　*masculine*

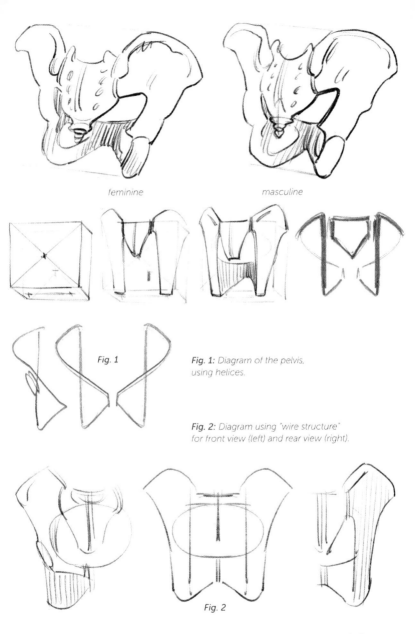

feminine

masculine

Fig. 1

Fig. 1: Diagram of the pelvis, using helices.

Fig. 2: Diagram using "wire structure" for front view (left) and rear view (right).

Fig. 2

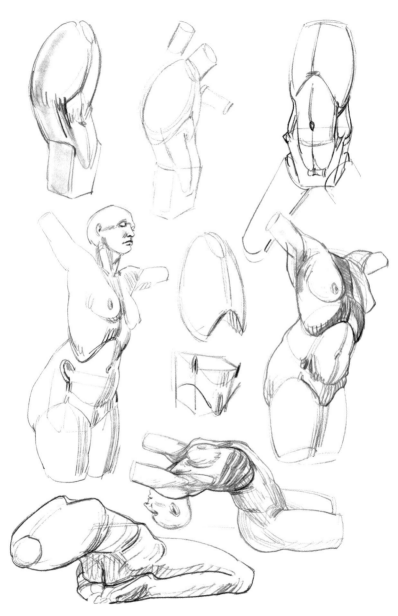

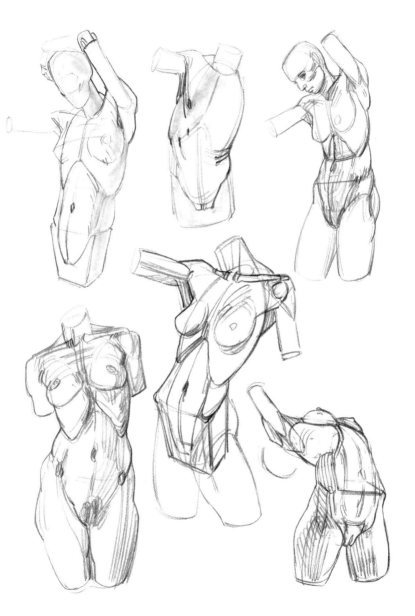

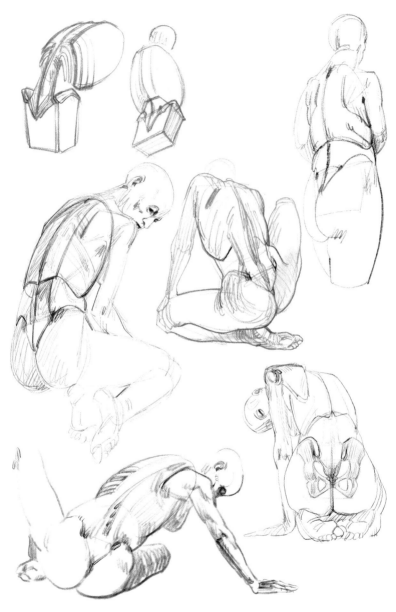

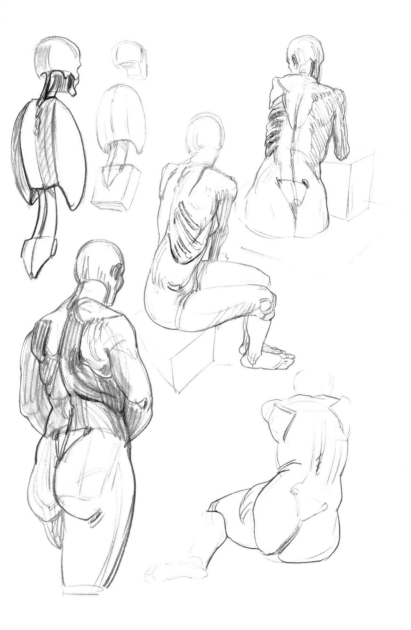

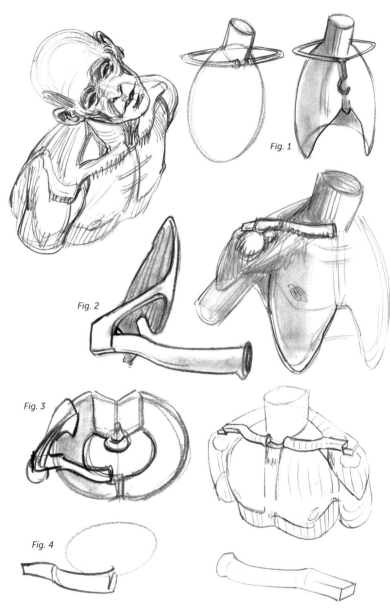

Fig. 1

Fig. 2

Fig. 3

Fig. 4

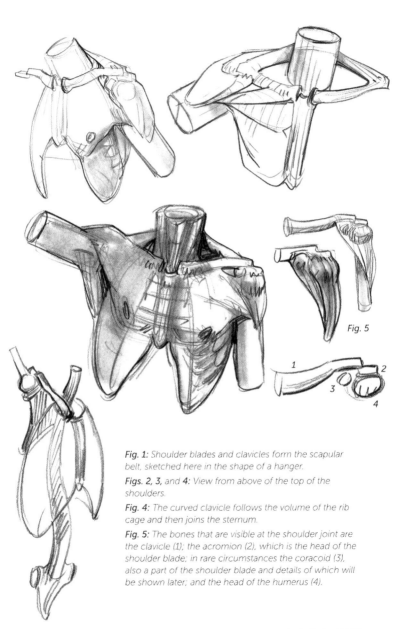

Fig. 1: *Shoulder blades and clavicles form the scapular belt, sketched here in the shape of a hanger.*

Figs. 2, 3, and **4:** *View from above of the top of the shoulders.*

Fig. 4: *The curved clavicle follows the volume of the rib cage and then joins the sternum.*

Fig. 5: *The bones that are visible at the shoulder joint are the clavicle (1); the acromion (2), which is the head of the shoulder blade; in rare circumstances the coracoid (3), also a part of the shoulder blade and details of which will be shown later; and the head of the humerus (4).*

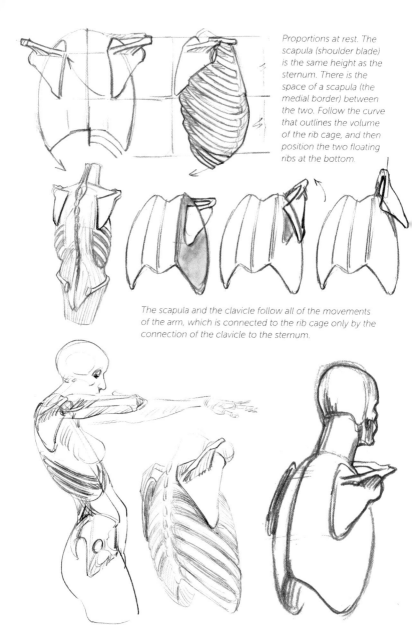

Proportions at rest. The scapula (shoulder blade) is the same height as the sternum. There is the space of a scapula (the medial border) between the two. Follow the curve that outlines the volume of the rib cage, and then position the two floating ribs at the bottom.

The scapula and the clavicle follow all of the movements of the arm, which is connected to the rib cage only by the connection of the clavicle to the sternum.

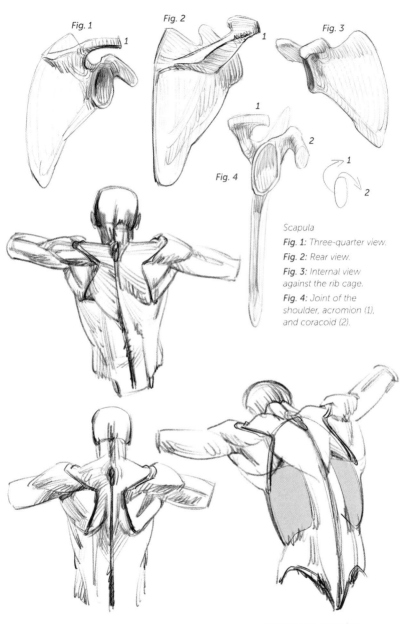

Fig. 1

Fig. 2

Fig. 3

Fig. 4

1

1

1

2

1

2

Scapula
Fig. 1: Three-quarter view.
Fig. 2: Rear view.
Fig. 3: Internal view against the rib cage.
Fig. 4: Joint of the shoulder, acromion (1), and coracoid (2).

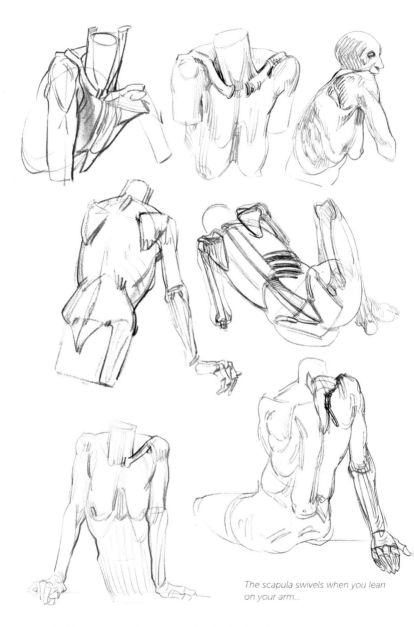

The scapula swivels when you lean on your arm...

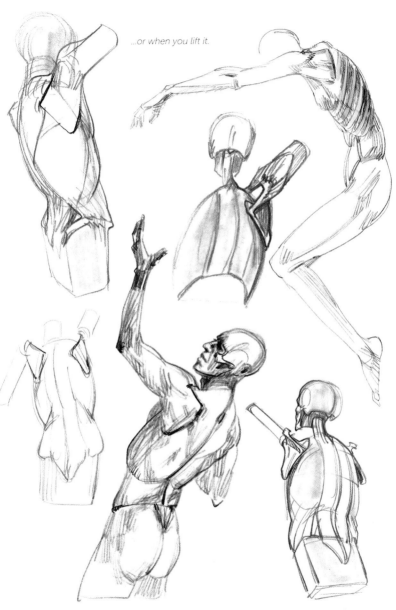

...or when you lift it.

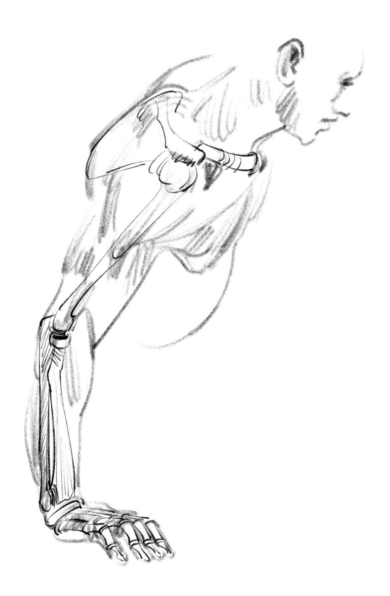

upper limb

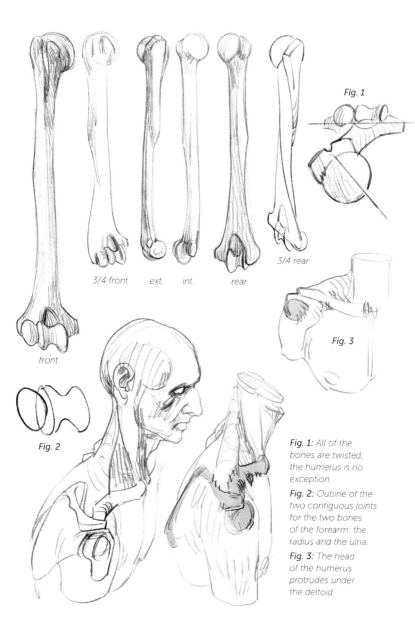

3/4 front ext. int. rear

3/4 rear

front

Fig. 1

Fig. 2

Fig. 3

Fig. 1: All of the bones are twisted; the humerus is no exception.

Fig. 2: Outline of the two contiguous joints for the two bones of the forearm: the radius and the ulna.

Fig. 3: The head of the humerus protrudes under the deltoid.

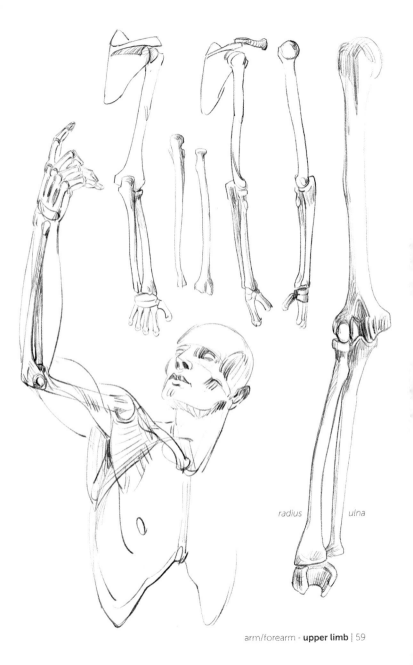

radius *ulna*

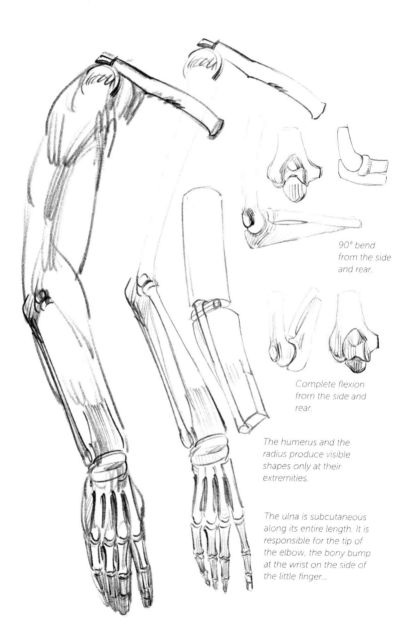

90° bend from the side and rear.

Complete flexion from the side and rear.

The humerus and the radius produce visible shapes only at their extremities.

The ulna is subcutaneous along its entire length. It is responsible for the tip of the elbow, the bony bump at the wrist on the side of the little finger...

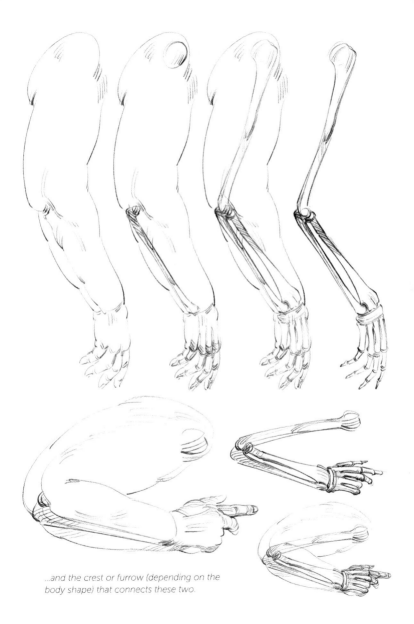

...and the crest or furrow (depending on the body shape) that connects these two.

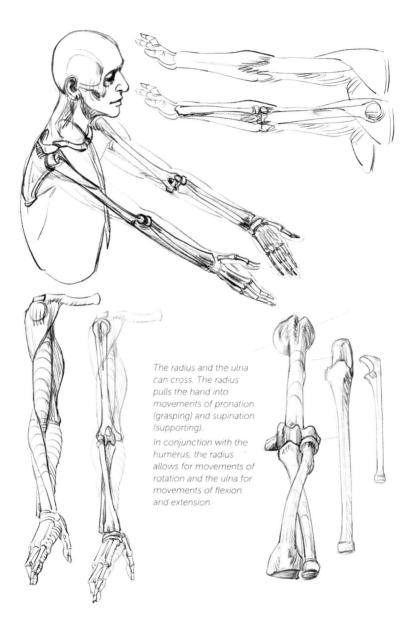

The radius and the ulna can cross. The radius pulls the hand into movements of pronation (grasping) and supination (supporting).

In conjunction with the humerus, the radius allows for movements of rotation and the ulna for movements of flexion and extension.

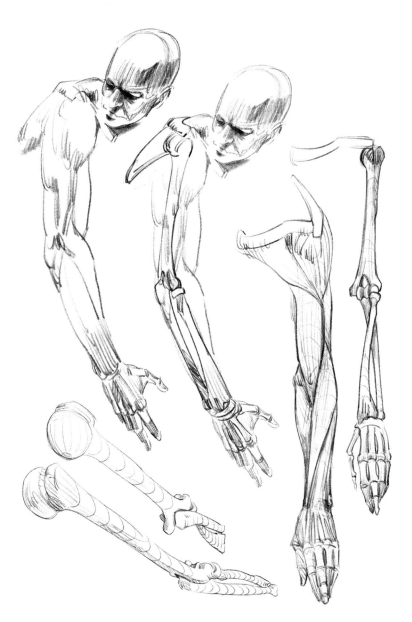

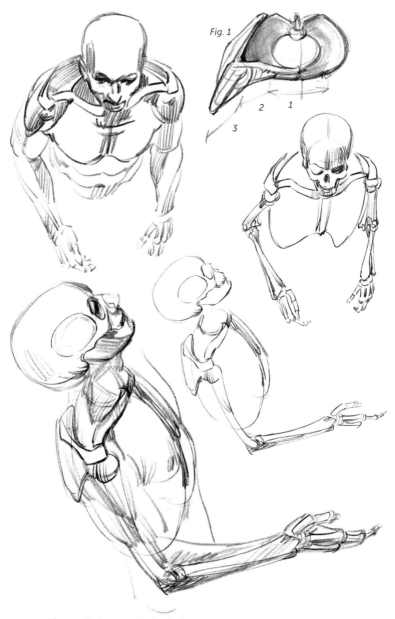

Fig. 1

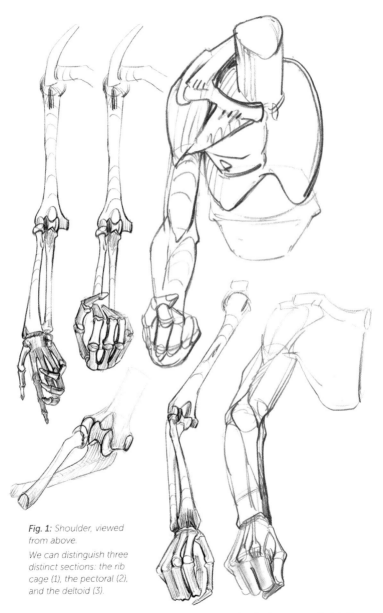

Fig. 1: Shoulder, viewed from above.

We can distinguish three distinct sections: the rib cage (1), the pectoral (2), and the deltoid (3).

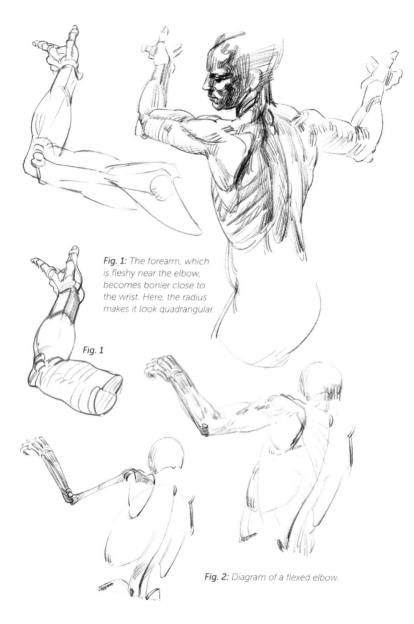

Fig. 1: The forearm, which is fleshy near the elbow, becomes bonier close to the wrist. Here, the radius makes it look quadrangular.

Fig. 1

Fig. 2: Diagram of a flexed elbow.

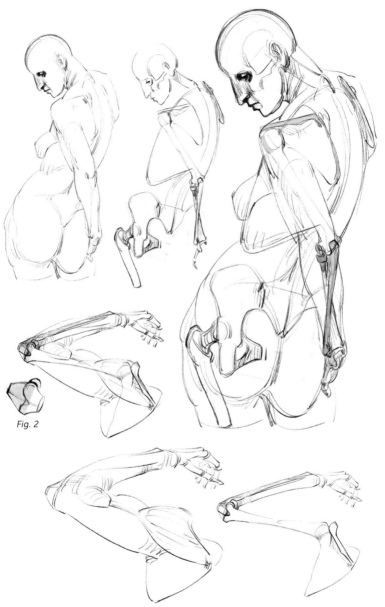

Fig. 2

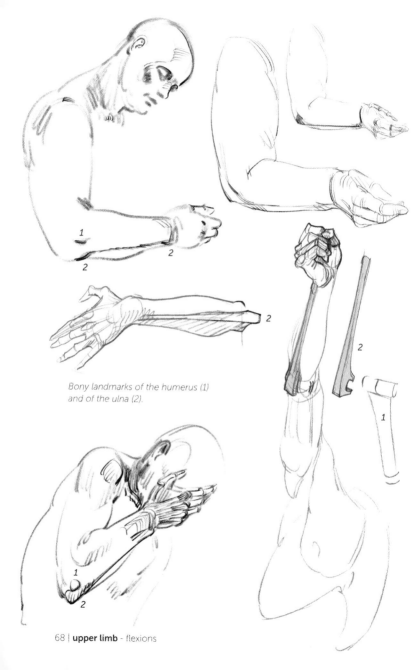

Bony landmarks of the humerus (1) and of the ulna (2).

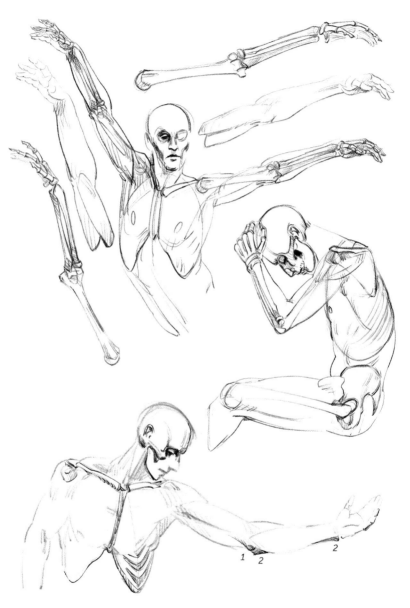

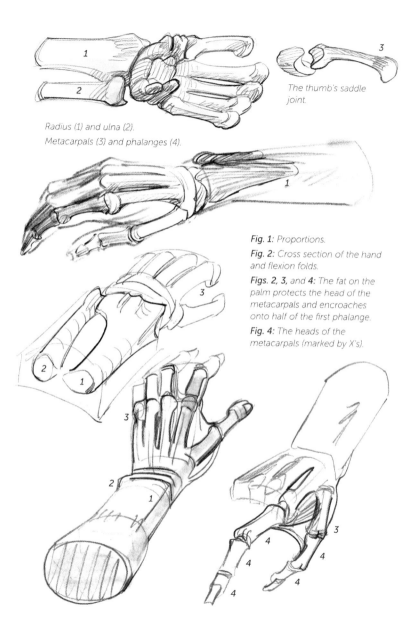

Radius (1) and ulna (2).
Metacarpals (3) and phalanges (4).

The thumb's saddle joint.

Fig. 1: Proportions.

Fig. 2: Cross section of the hand and flexion folds.

Figs. 2, 3, and 4: The fat on the palm protects the head of the metacarpals and encroaches onto half of the first phalange.

Fig. 4: The heads of the metacarpals (marked by X's).

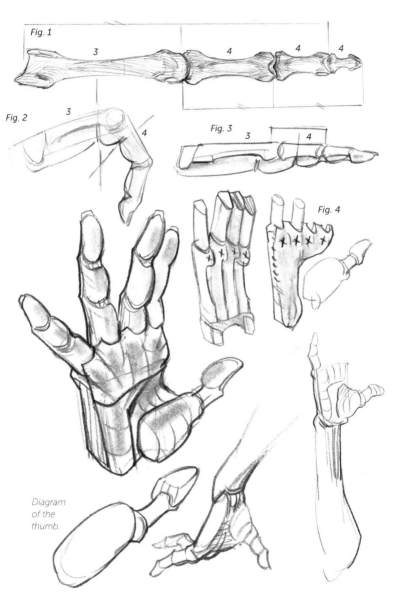

Fig. 1

Fig. 2

Fig. 3

Fig. 4

Diagram of the thumb.

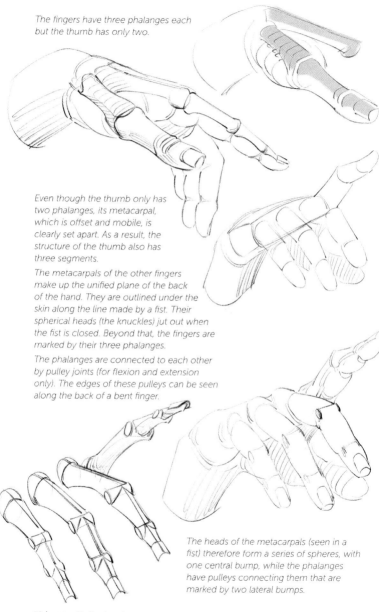

The fingers have three phalanges each but the thumb has only two.

Even though the thumb only has two phalanges, its metacarpal, which is offset and mobile, is clearly set apart. As a result, the structure of the thumb also has three segments.

The metacarpals of the other fingers make up the unified plane of the back of the hand. They are outlined under the skin along the line made by a fist. Their spherical heads (the knuckles) jut out when the fist is closed. Beyond that, the fingers are marked by their three phalanges.

The phalanges are connected to each other by pulley joints (for flexion and extension only). The edges of these pulleys can be seen along the back of a bent finger.

The heads of the metacarpals (seen in a fist) therefore form a series of spheres, with one central bump, while the phalanges have pulleys connecting them that are marked by two lateral bumps.

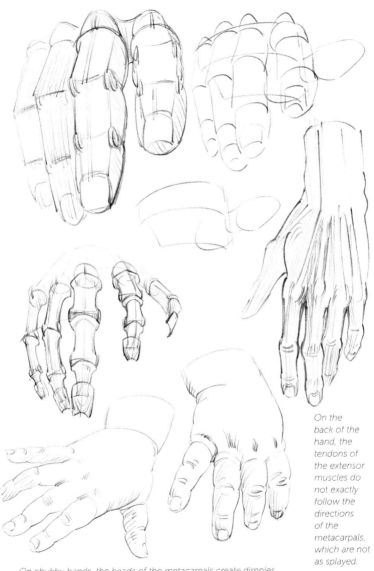

On the back of the hand, the tendons of the extensor muscles do not exactly follow the directions of the metacarpals, which are not as splayed.

On chubby hands, the heads of the metacarpals create dimples.

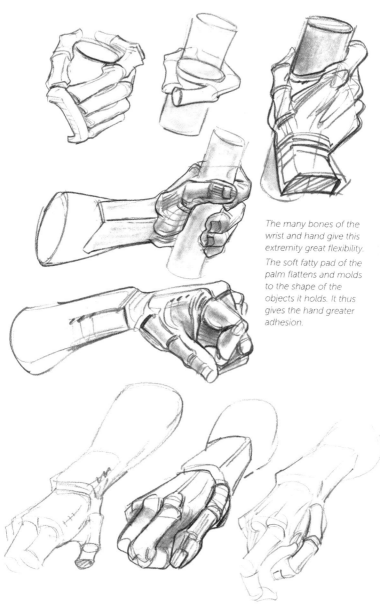

The many bones of the wrist and hand give this extremity great flexibility.

The soft fatty pad of the palm flattens and molds to the shape of the objects it holds. It thus gives the hand greater adhesion.

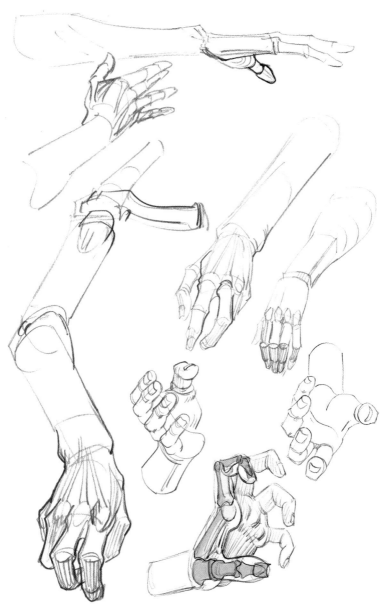

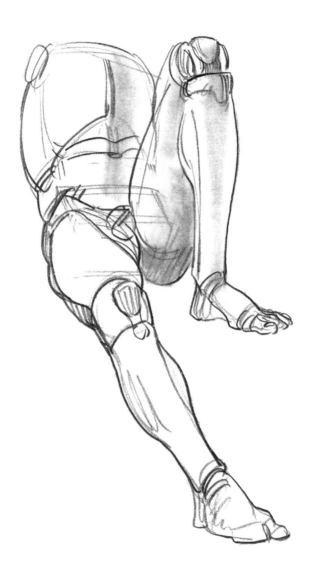

lower limb

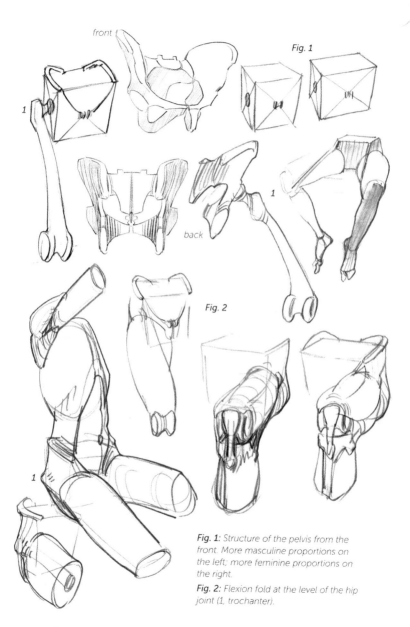

front

Fig. 1

back

Fig. 2

1

Fig. 1: *Structure of the pelvis from the front. More masculine proportions on the left; more feminine proportions on the right.*

Fig. 2: *Flexion fold at the level of the hip joint (1, trochanter).*

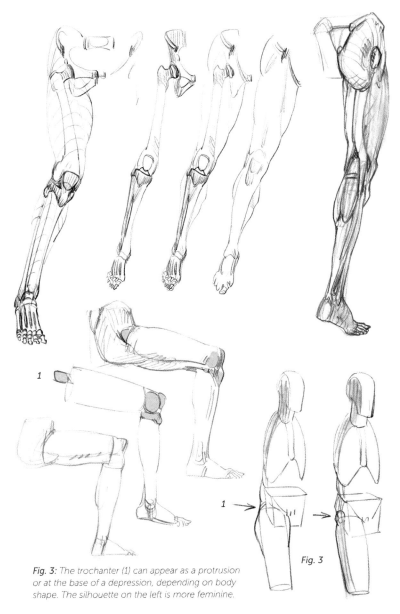

Fig. 3: The trochanter (1) can appear as a protrusion or at the base of a depression, depending on body shape. The silhouette on the left is more feminine.

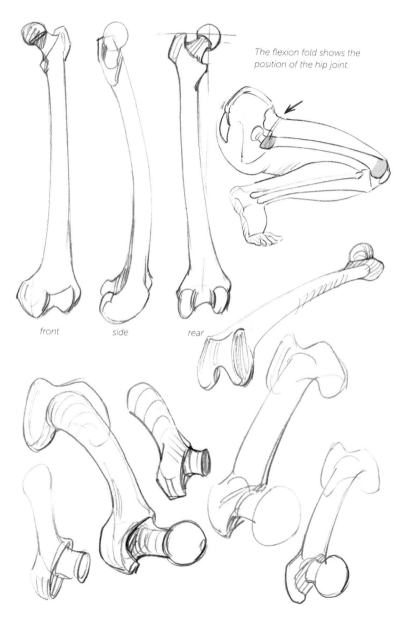

The flexion fold shows the position of the hip joint.

front *side* *rear*

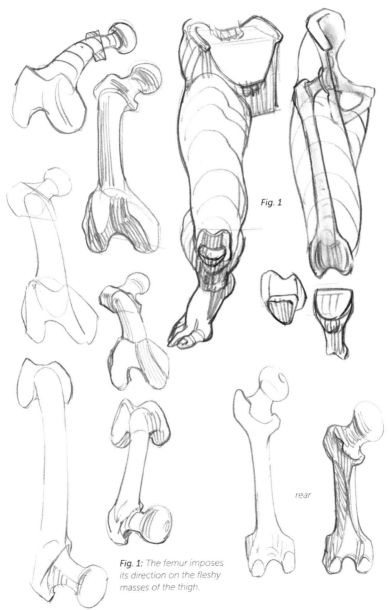

Fig. 1

Fig. 1: The femur imposes its direction on the fleshy masses of the thigh.

rear

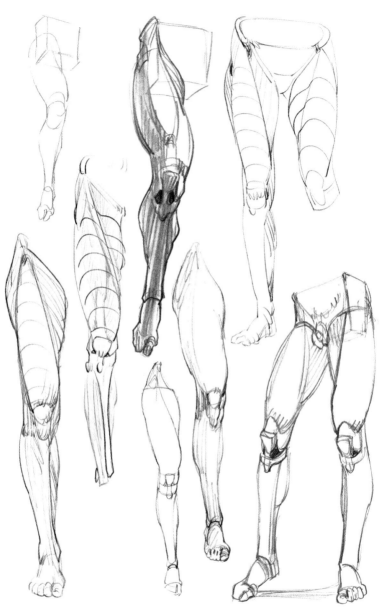

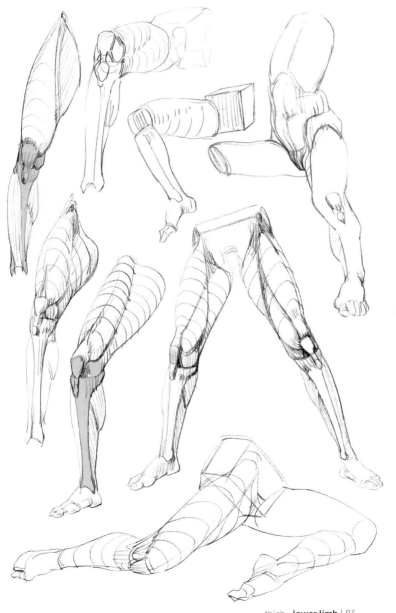

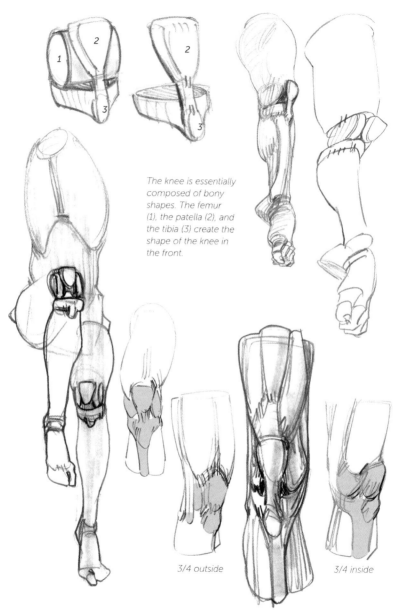

The knee is essentially composed of bony shapes. The femur (1), the patella (2), and the tibia (3) create the shape of the knee in the front.

3/4 outside

3/4 inside

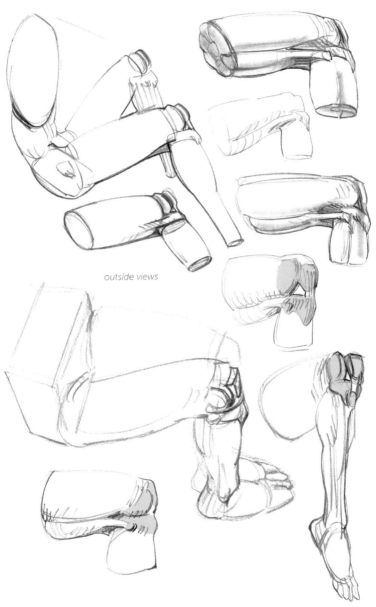

outside views

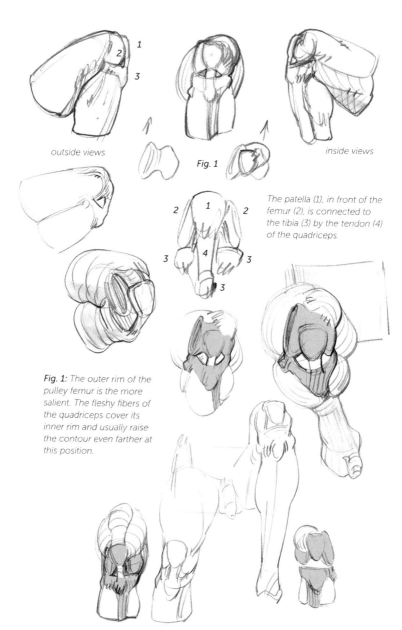

outside views

Fig. 1

inside views

The patella (1), in front of the femur (2), is connected to the tibia (3) by the tendon (4) of the quadriceps.

Fig. 1: The outer rim of the pulley femur is the more salient. The fleshy fibers of the quadriceps cover its inner rim and usually raise the contour even farther at this position.

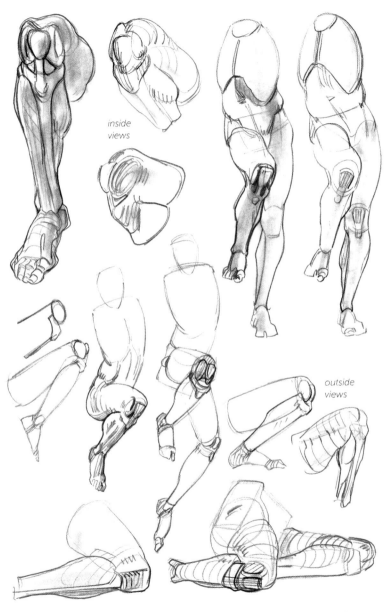

inside views

outside views

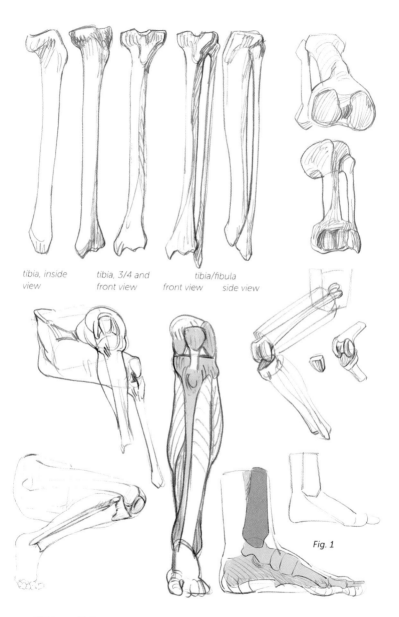

tibia, inside view

tibia, 3/4 and front view

tibia/fibula front view

side view

Fig. 1

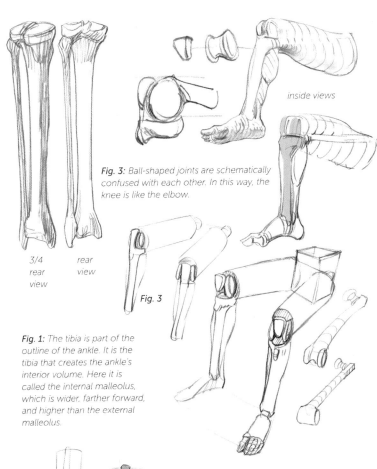

inside views

Fig. 3: *Ball-shaped joints are schematically confused with each other. In this way, the knee is like the elbow.*

3/4 rear view

rear view

Fig. 3

Fig. 1: *The tibia is part of the outline of the ankle. It is the tibia that creates the ankle's interior volume. Here it is called the internal malleolus, which is wider, farther forward, and higher than the external malleolus.*

Fig. 2

Fig. 2: *On the other side, the fibula completes this connection and corresponds to the external malleolus, which is thinner and more centrally located, and extends further down.*

In a front or rear view, the contours of the ankle are, therefore, not at the same level. Remember that the ankle is higher on the inside (raised side) of the foot, the side with the plantar arch.

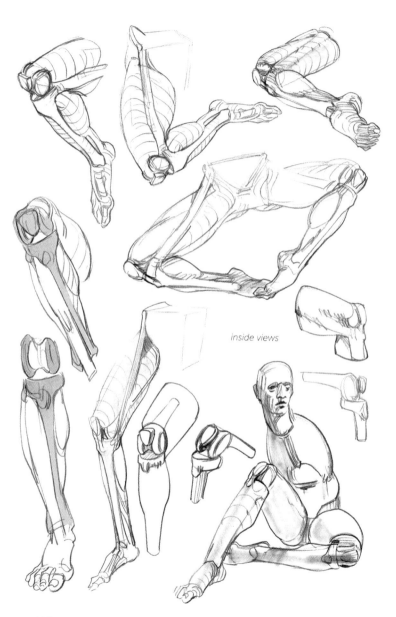

inside views

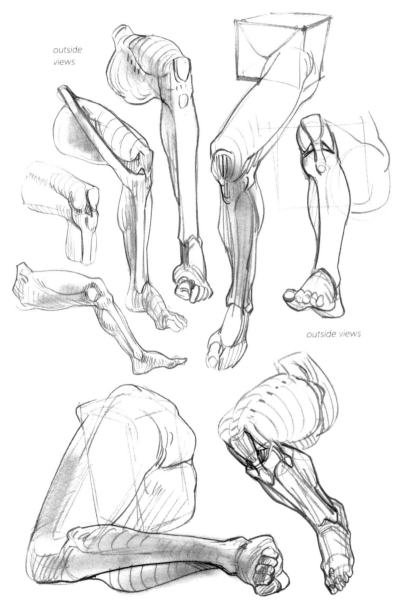

outside views

outside views

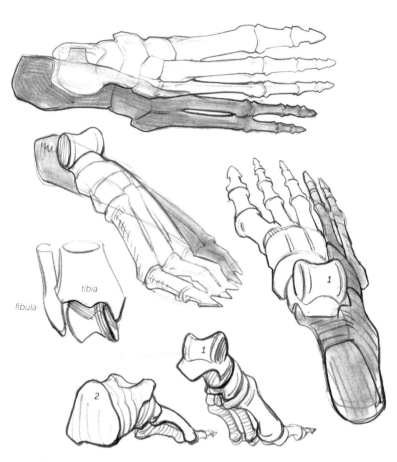

The foot can be divided into two parts. The first, dynamic part is raised in an extension of the talus (1), which joins the tibia and the fibula. This elevation is responsible for the plantar arch, which acts as a shock absorber. This is the side with the strongest toe, the big toe (hallux).

The second part of the foot is in the extension of the heel, or calcaneus (2), and it stays on the ground along the side of the little toe.

The footprint that a foot leaves on the ground, except in the case of a flat foot, takes this structure into account. The entire outer side of the foot leaves its impression, but on the inner side, the foot does not touch the ground and the footprint, therefore, indicates the arch.

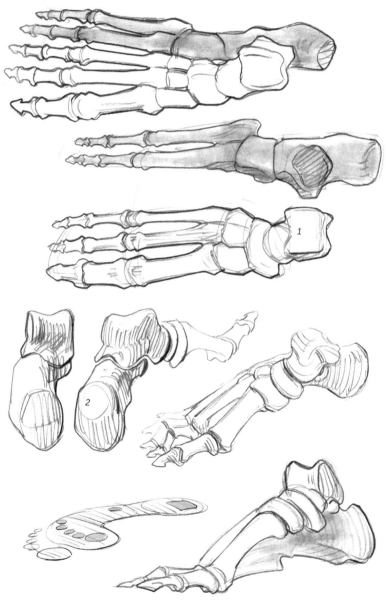

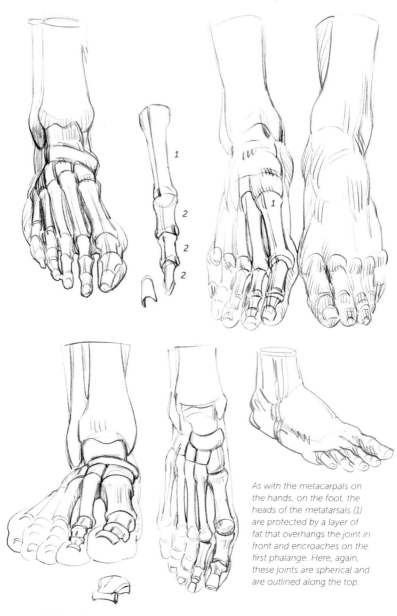

As with the metacarpals on the hands, on the foot, the heads of the metatarsals (1) are protected by a layer of fat that overhangs the joint in front and encroaches on the first phalange. Here, again, these joints are spherical and are outlined along the top.

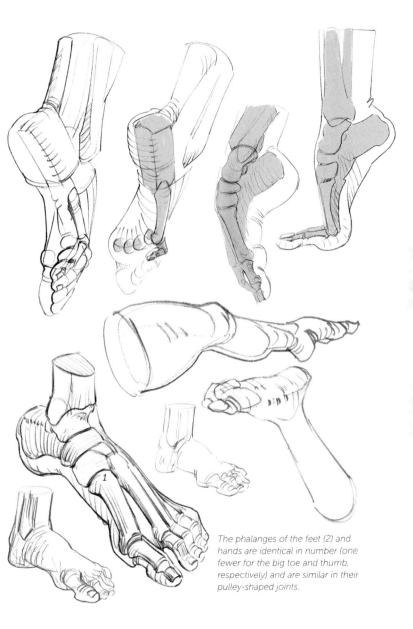

The phalanges of the feet (2) and hands are identical in number (one fewer for the big toe and thumb, respectively) and are similar in their pulley-shaped joints.

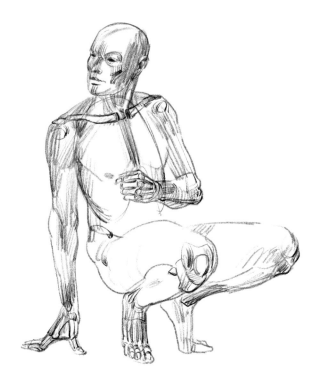

resources

Albinus on Anatomy,
Robert Beverly Hale
and Terence Coyle,
Dover Publications, New York, 1989

The Human Machine,
George B. Bridgman,
Dover Publications, New York, 1972

Constructive Anatomy,
George B. Bridgman,
Dover Publications, New York, 1973

Artistic Anatomy,
Paul Richer,
Watson-Guptill, New York, 1986

Anatomy for Artists,
Sarah Simblet,
DK Publishing, New York, 2001

For French speakers (from
the original French edition):
*Le dessin de nu: anatomie
et modèle vivant,*
Thomas Wienc,
Dessain et Tolra, Paris, 2010